CAT AT HOME

NOBUO HONDA

CHRONICLE BOOKS
SAN FRANCISCO

First published in the United States 1989 by Chronicle Books.

Printed in Japan.

The original edition of *The Japanese Cat at Home* was published
in Japan by Tokyo Shoseki Co., Ltd., Tokyo.

Distributed in Canada by Raincoast Books, 112 East Third
Avenue, Vancouver, B.C., V5T 1C8

10 9 8 7 6 5 4 3 2 1

ISBN: 0-87701-704-2

Chronicle Books
275 Fifth Street
San Francisco, California 94103

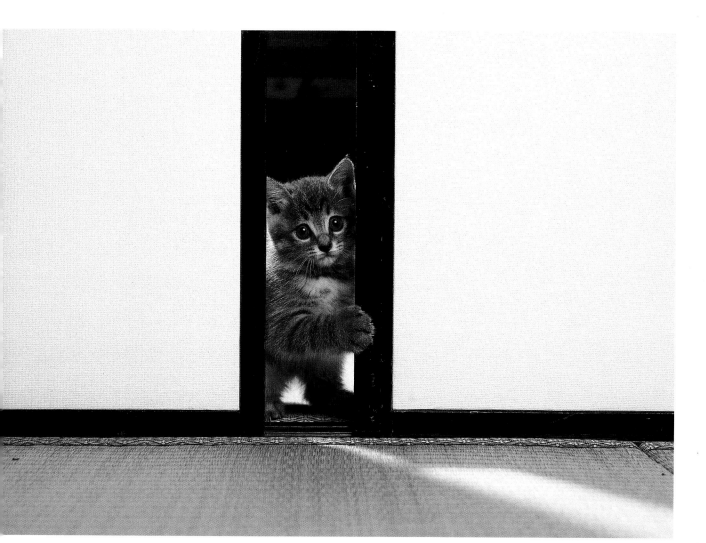

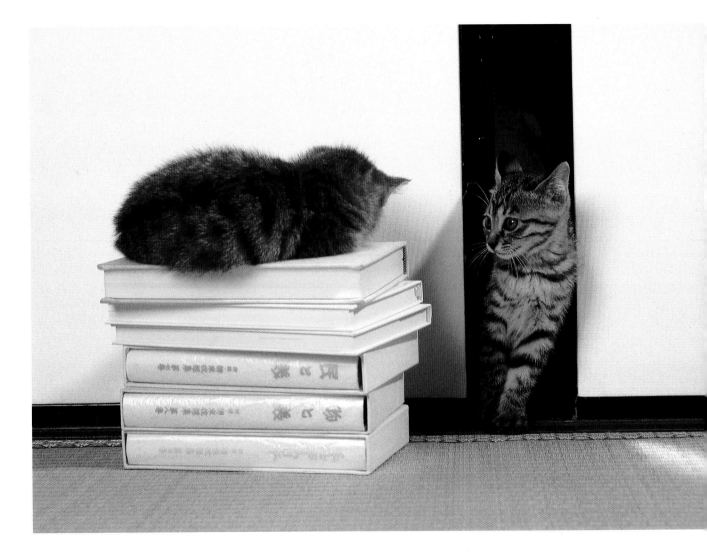

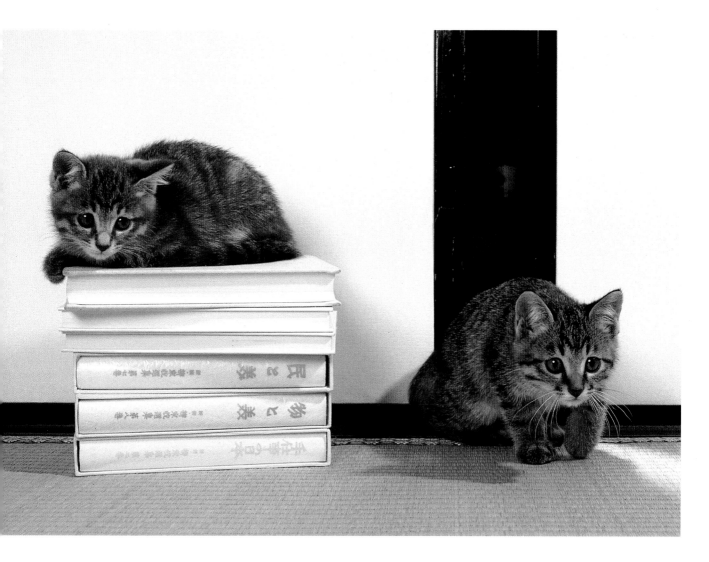

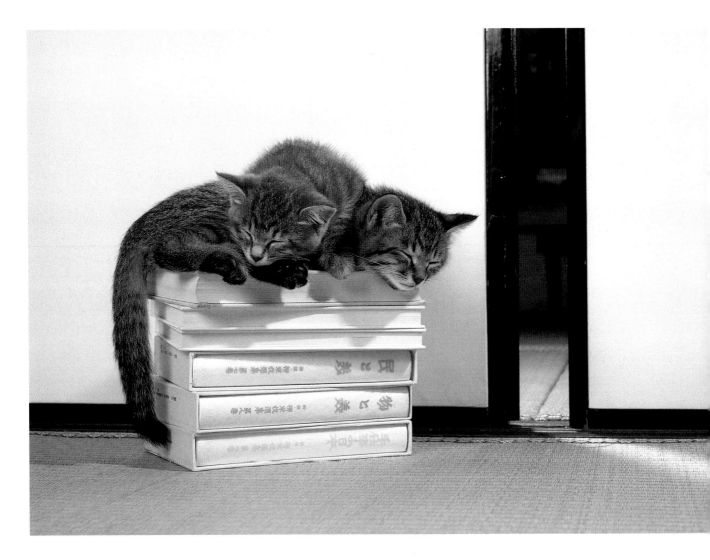

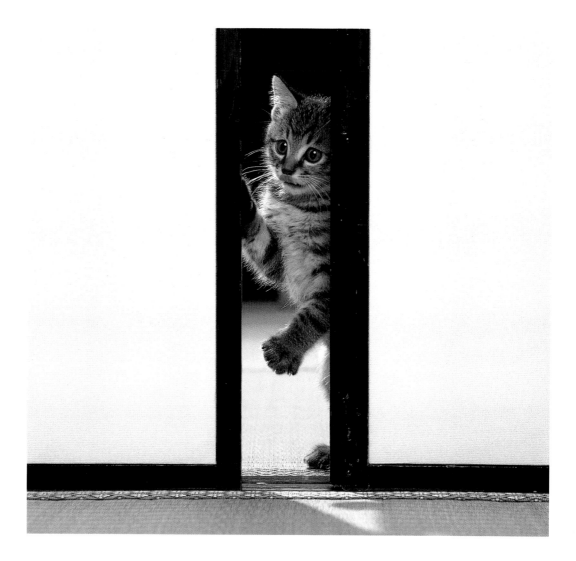

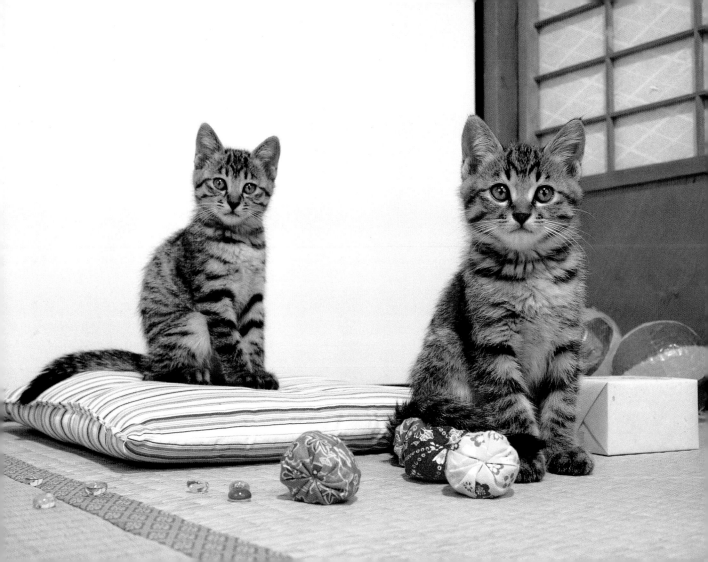

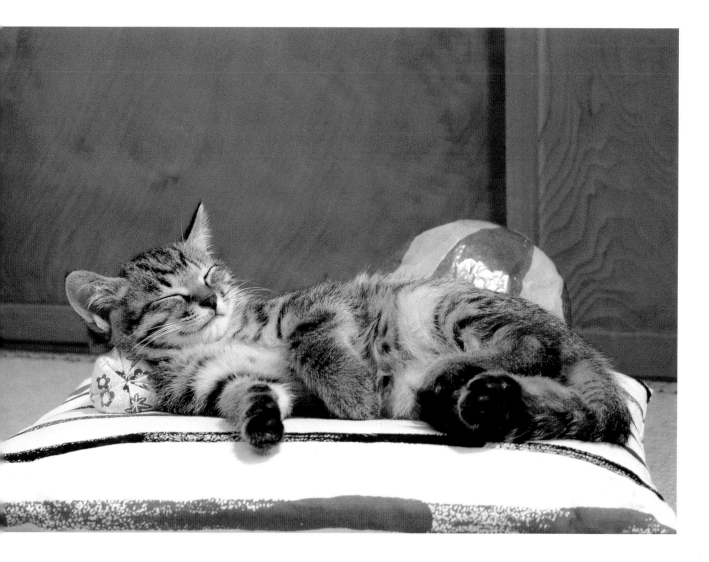

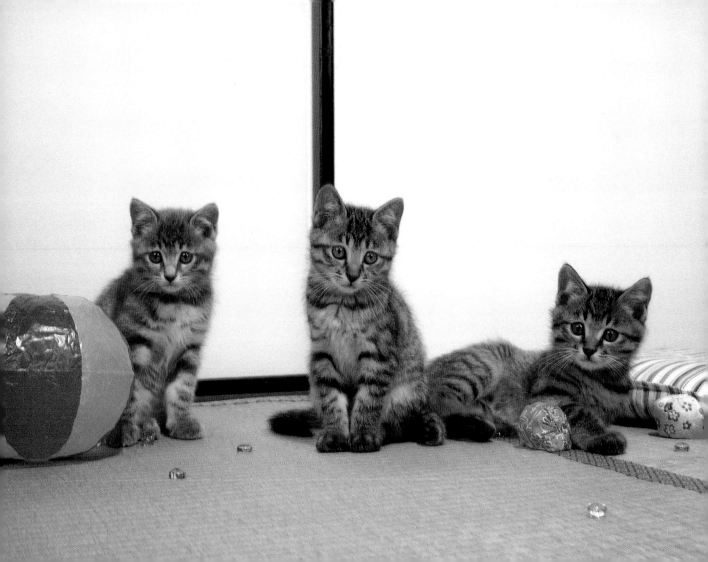

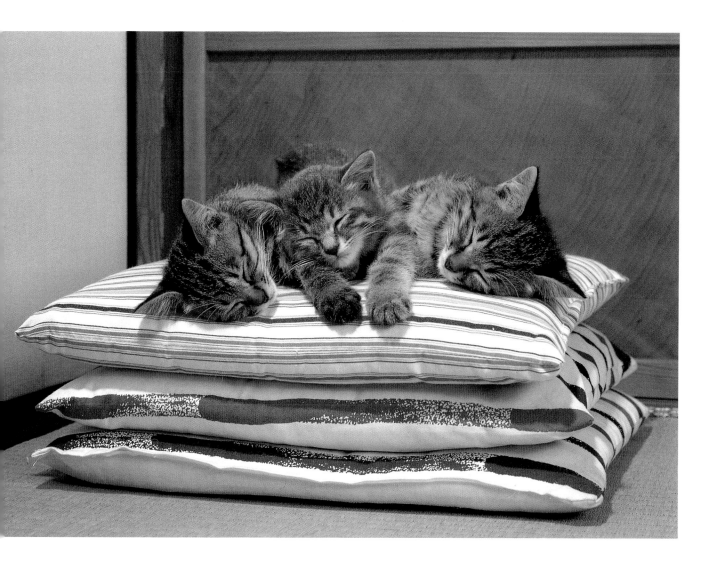

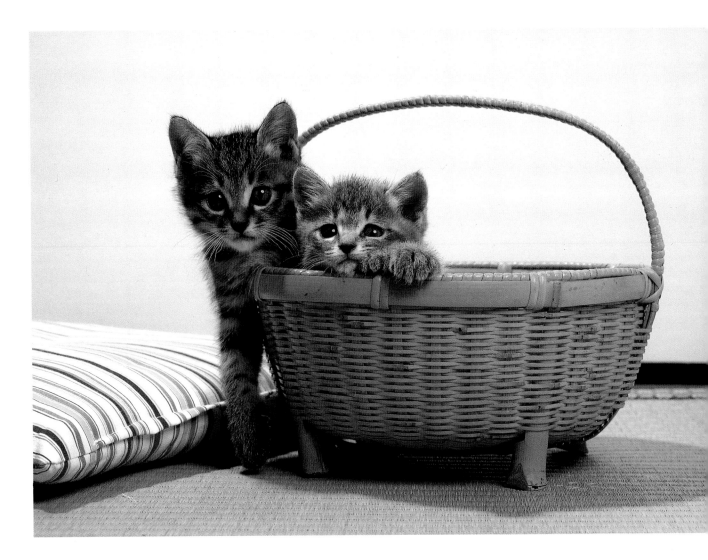

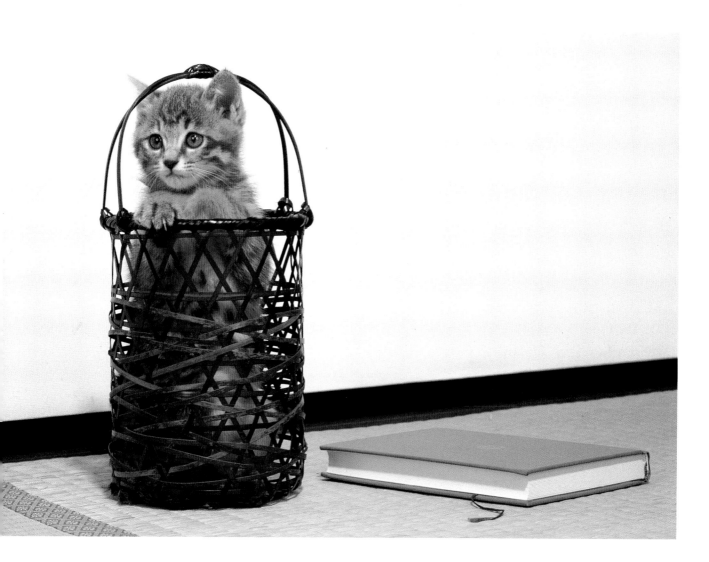

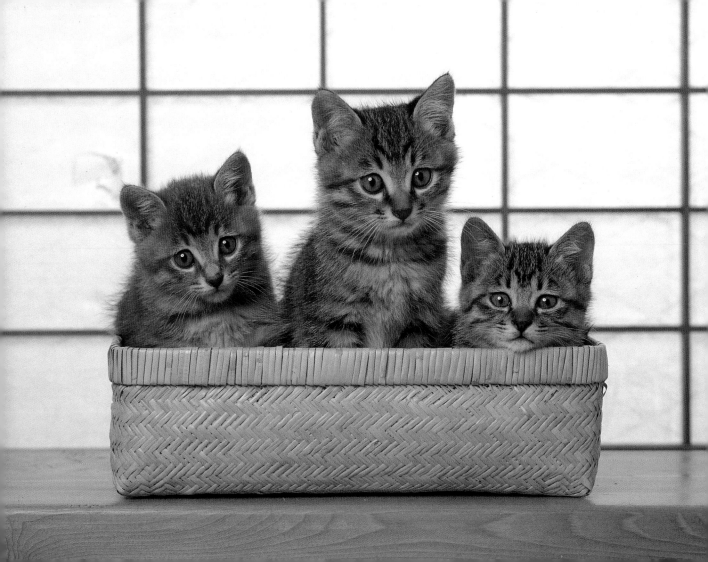

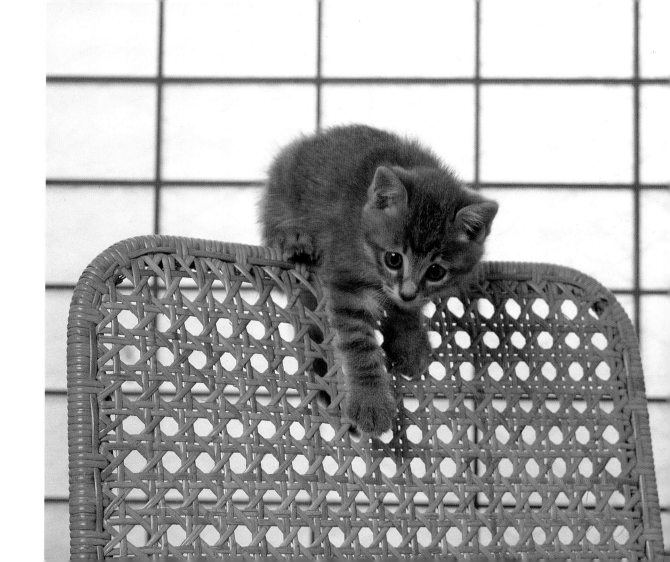

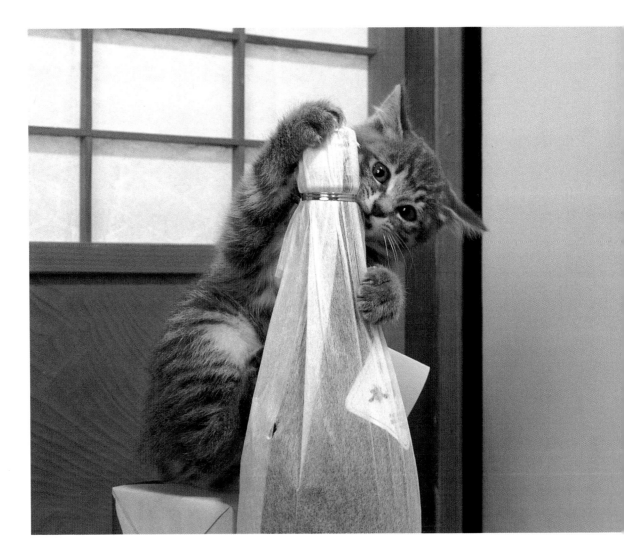

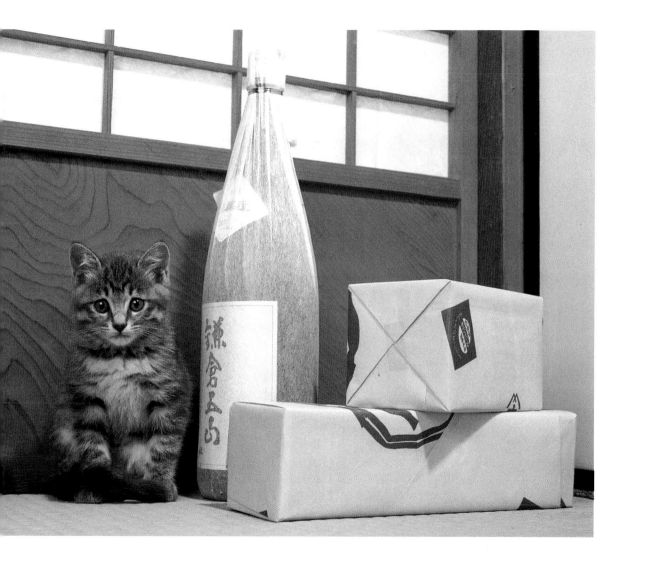

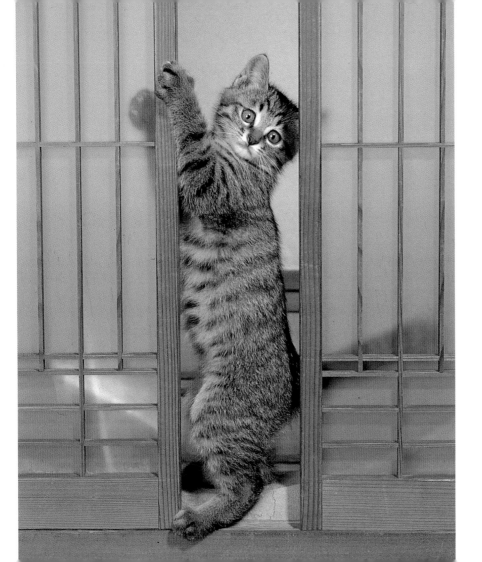

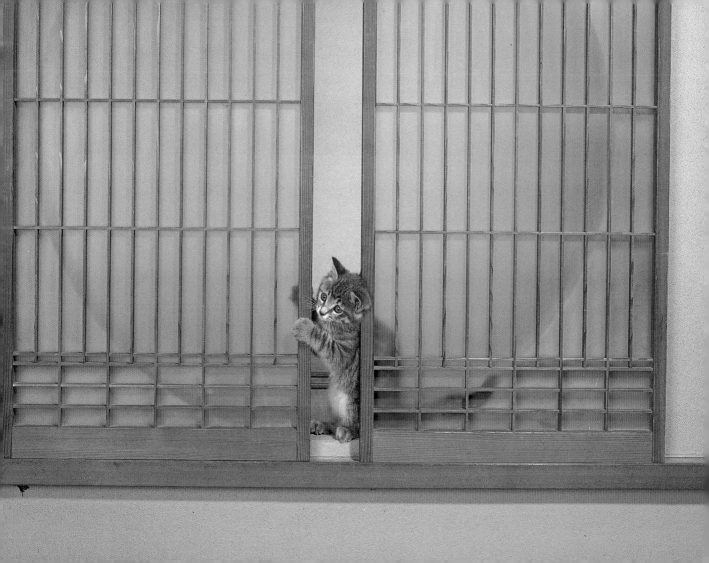

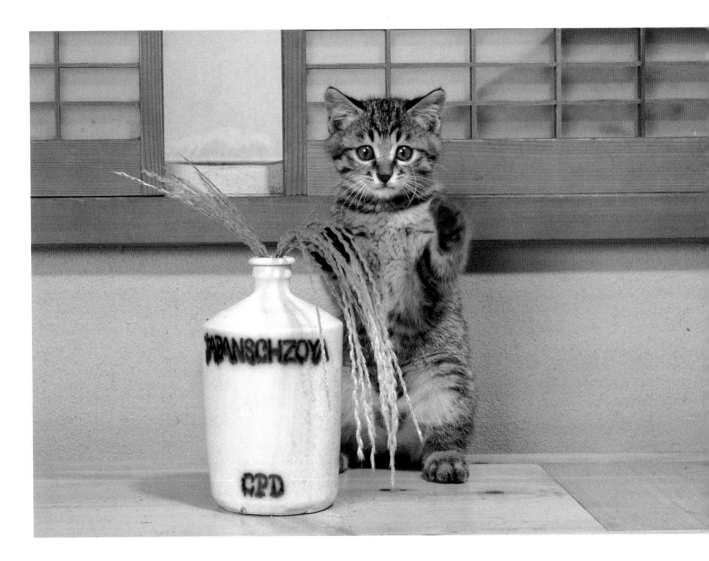

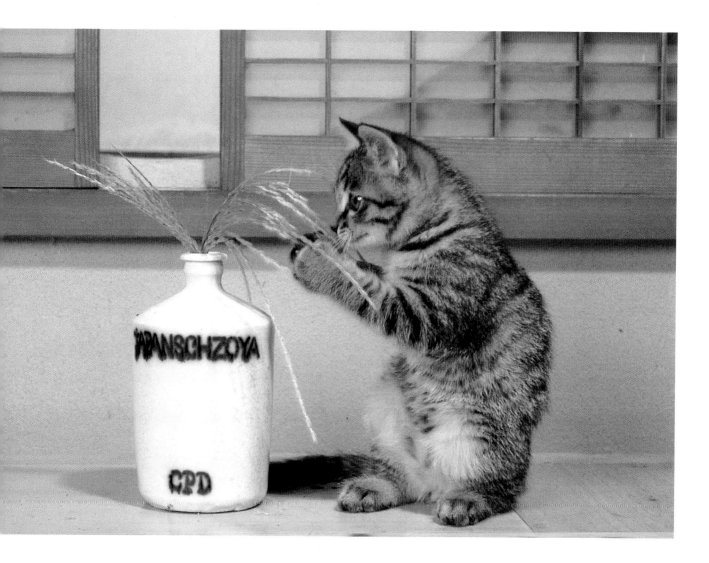

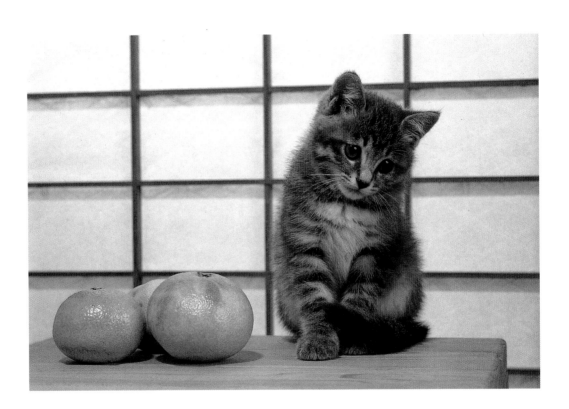

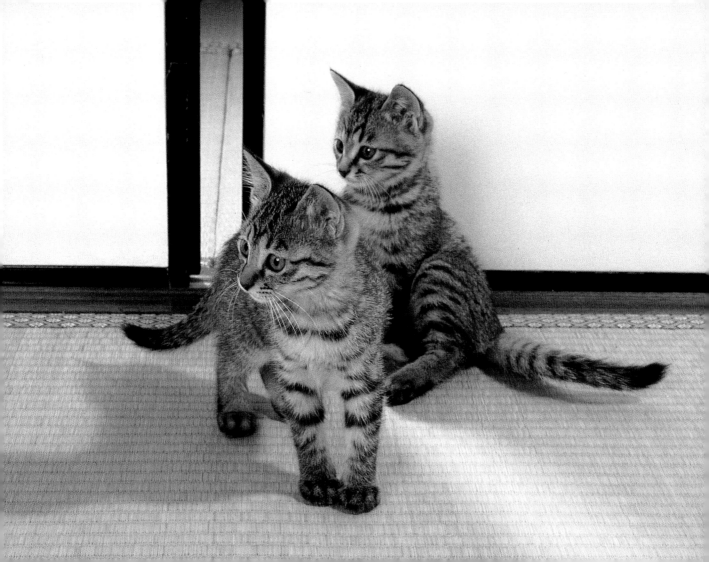

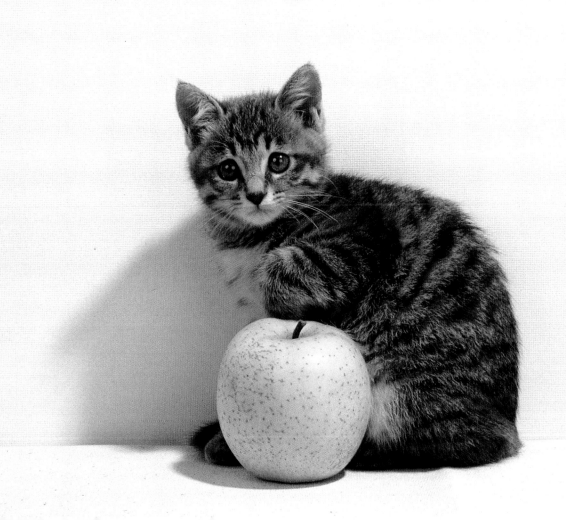

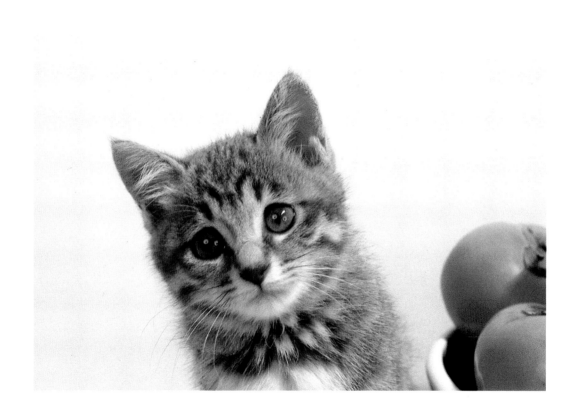

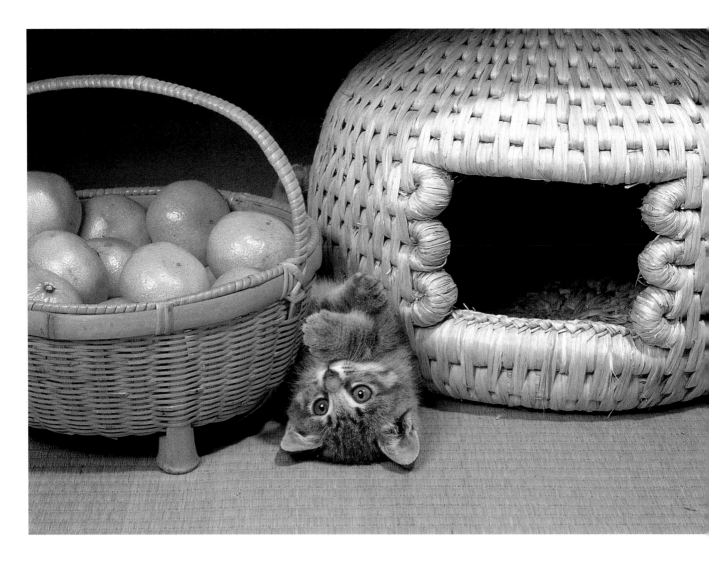

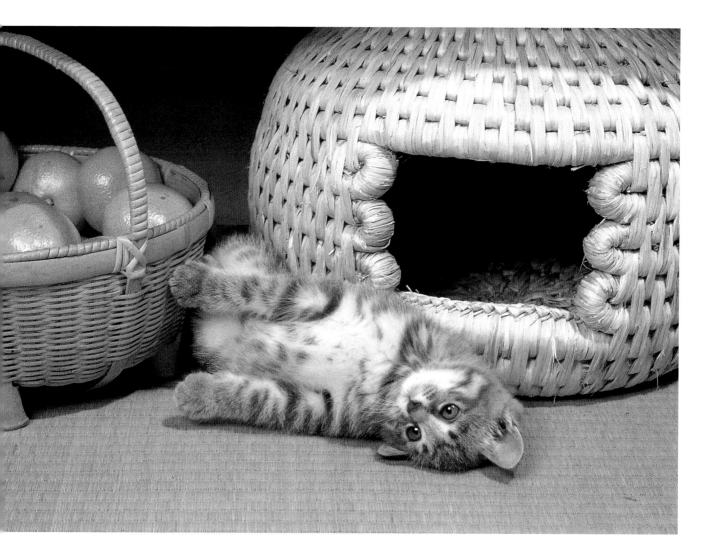

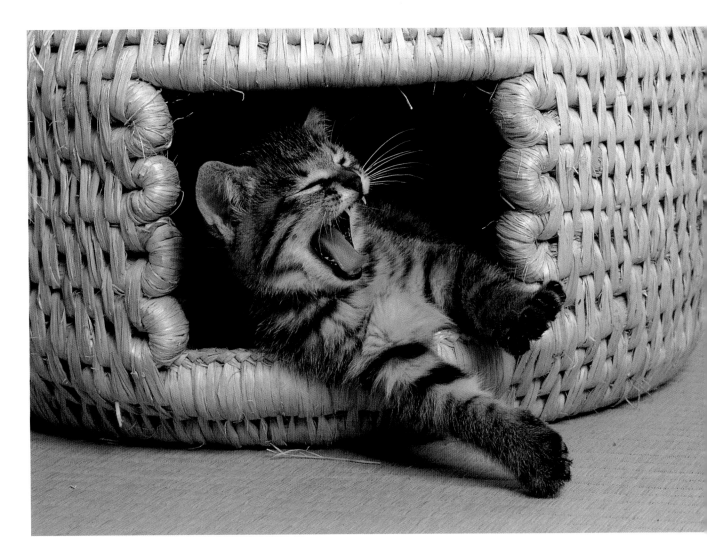

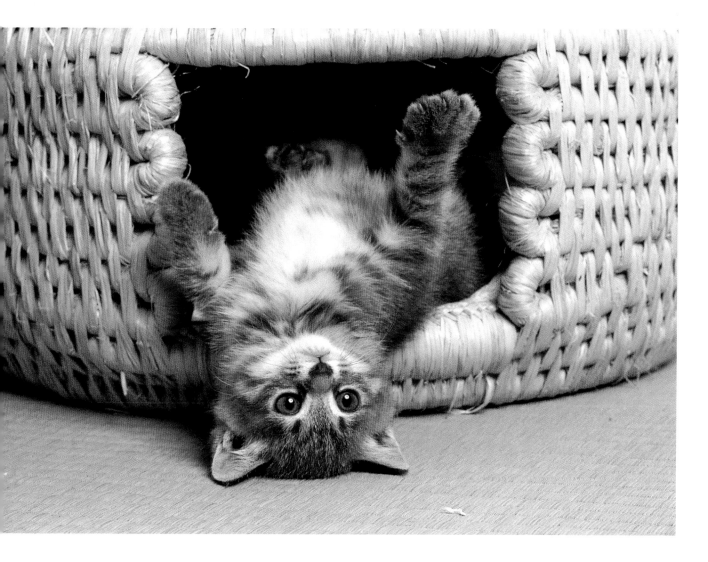

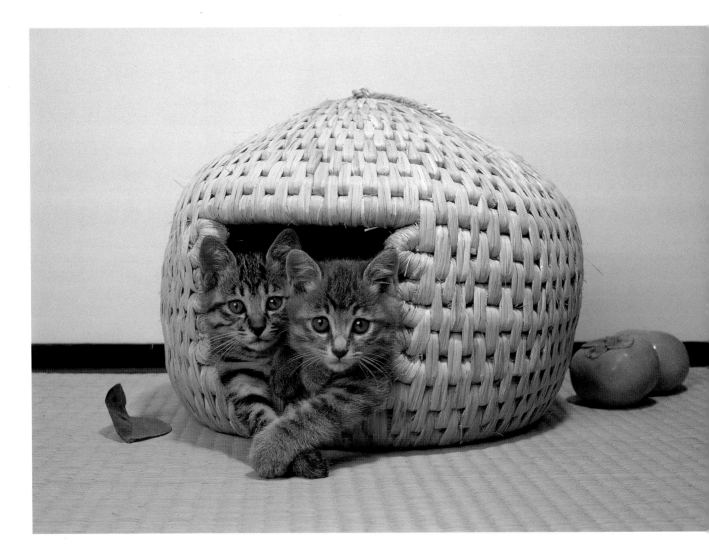

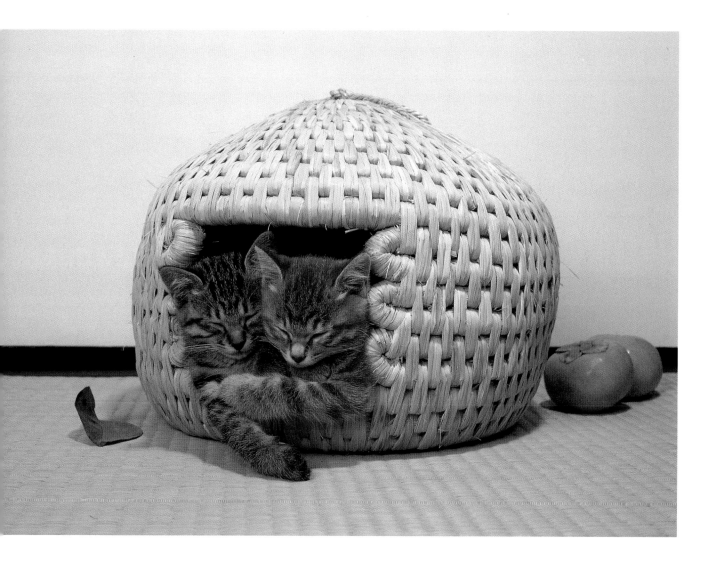

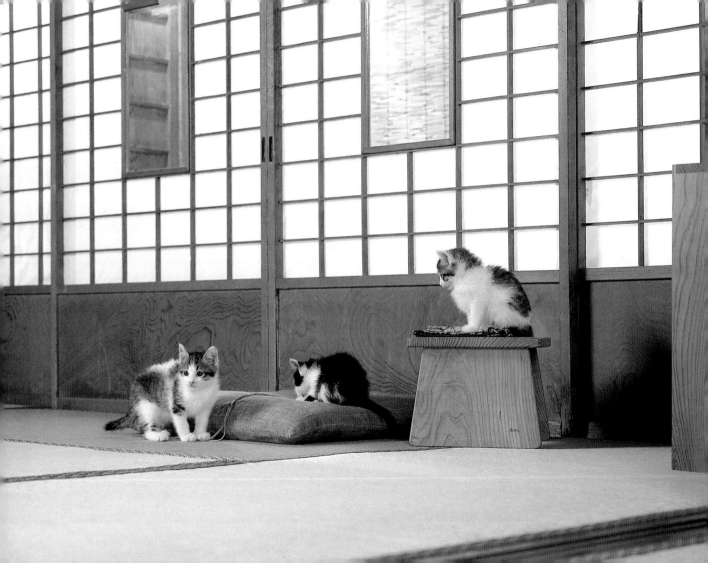

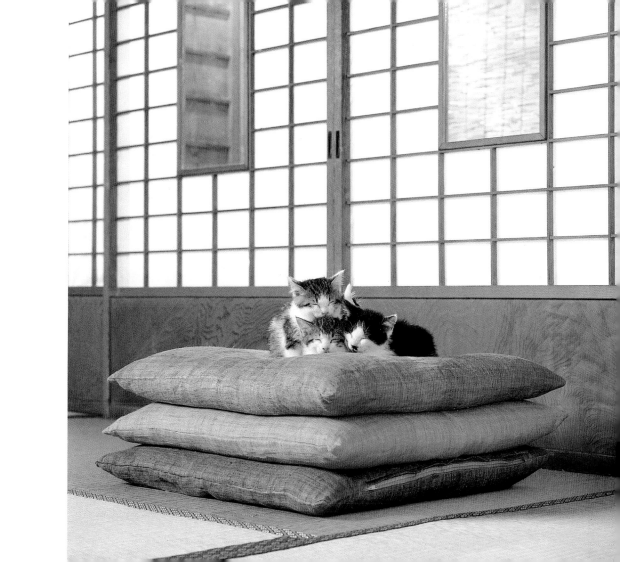

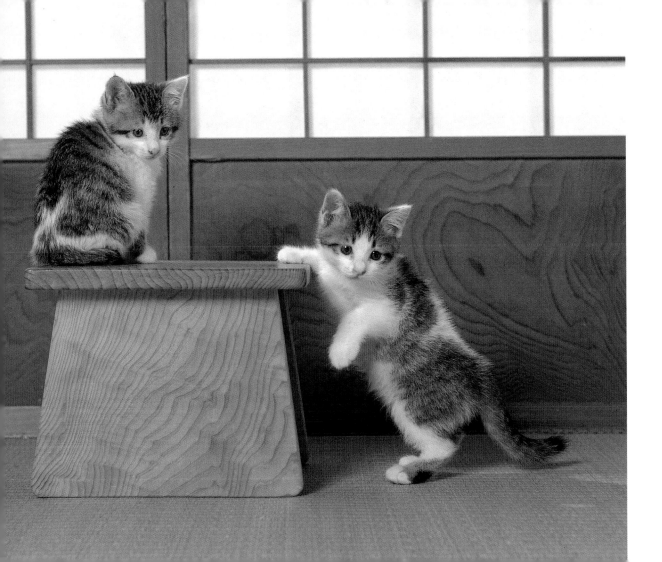

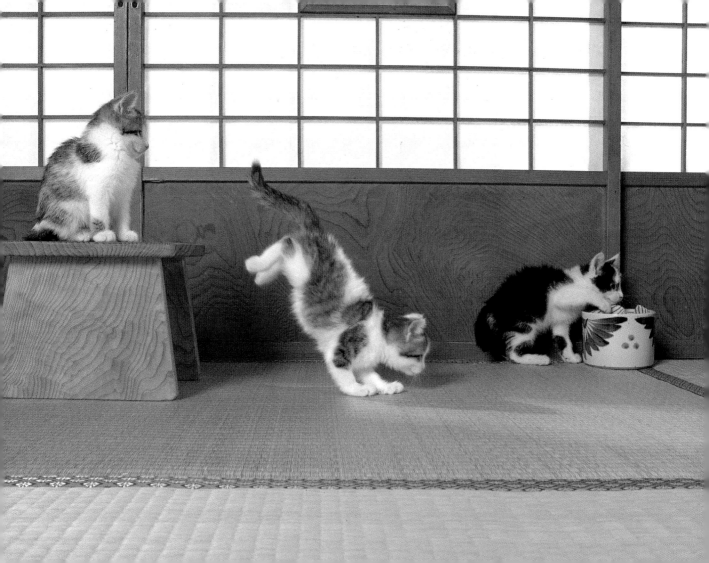

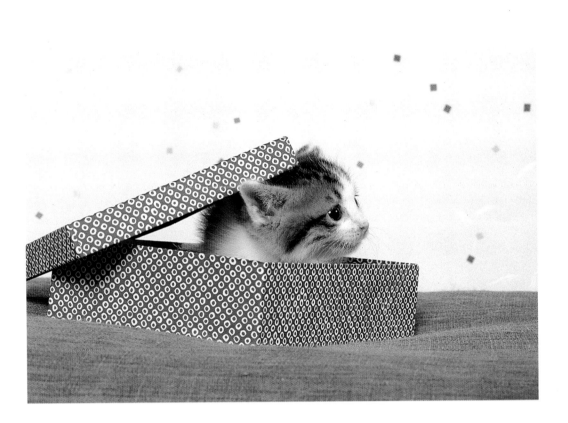

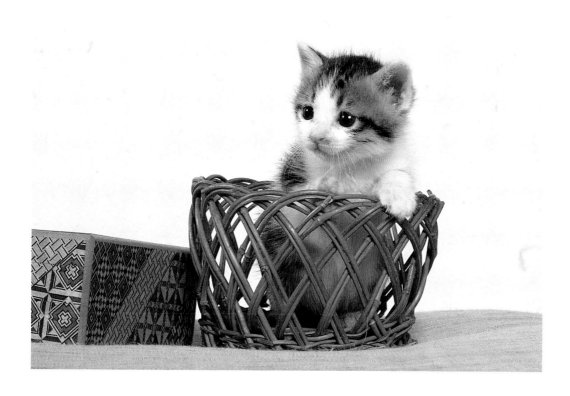

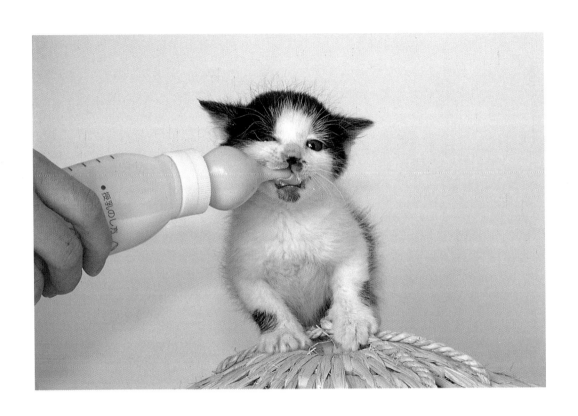

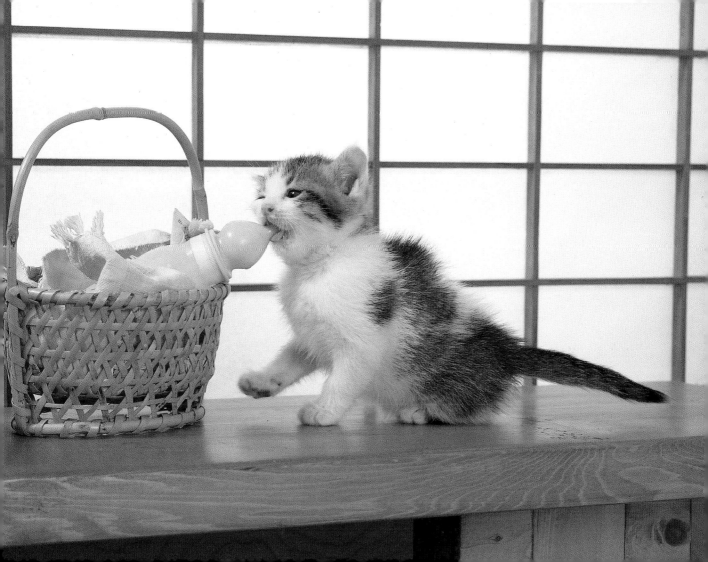

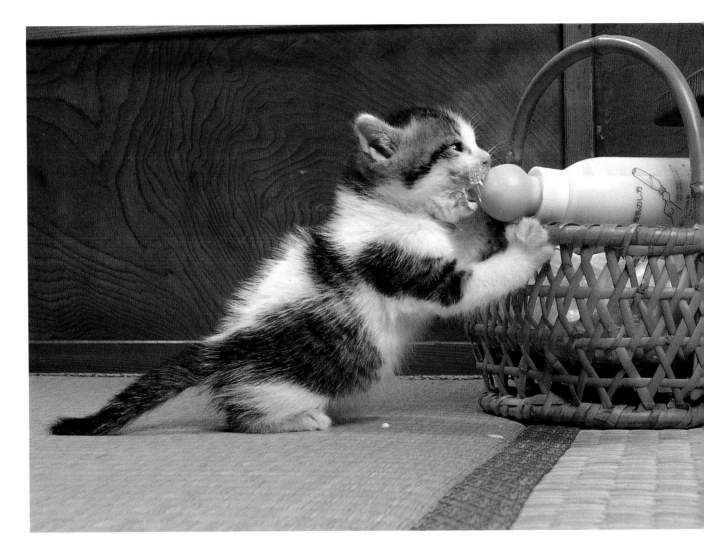

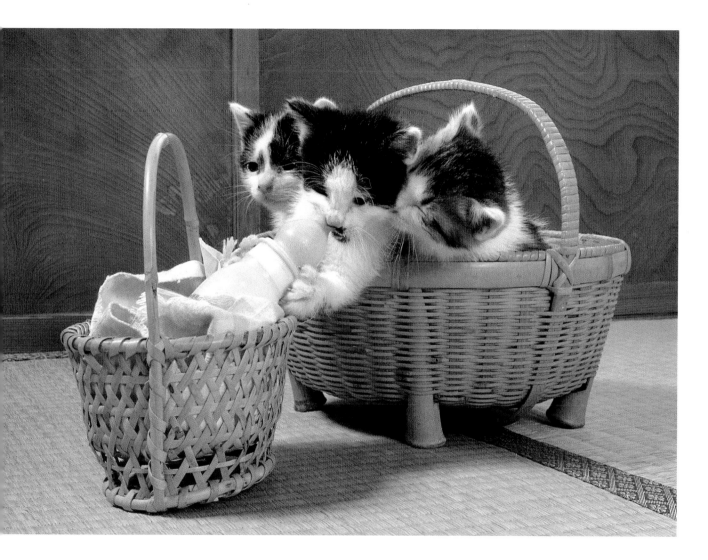

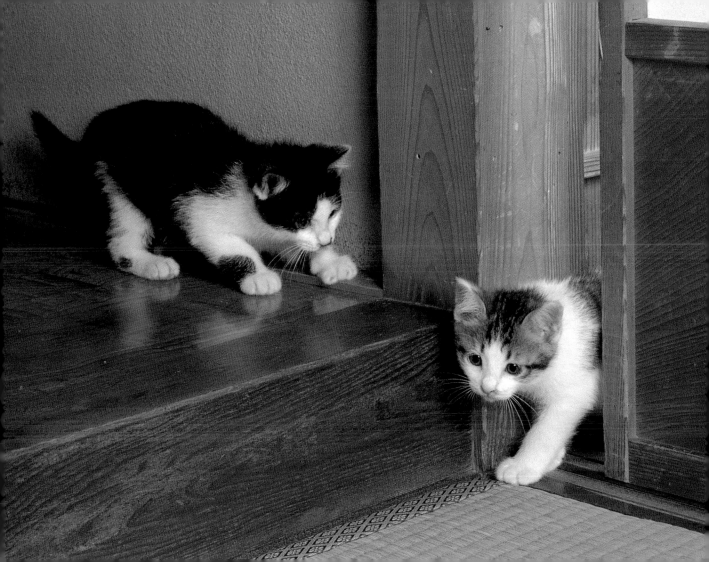

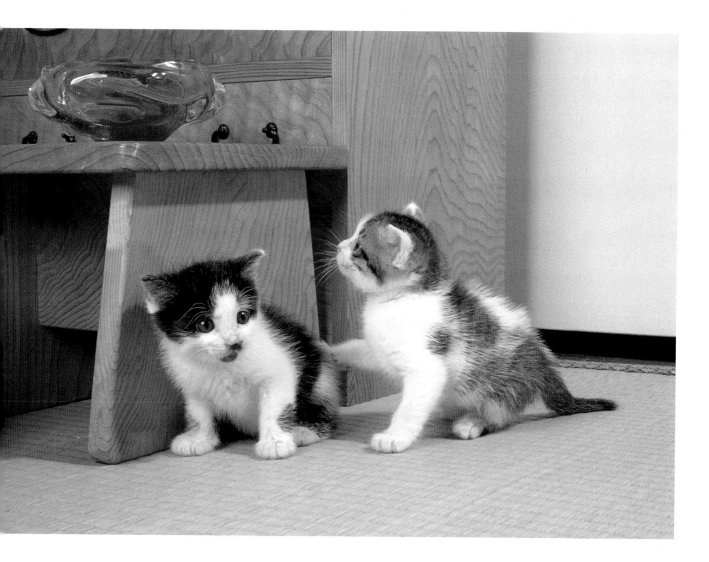

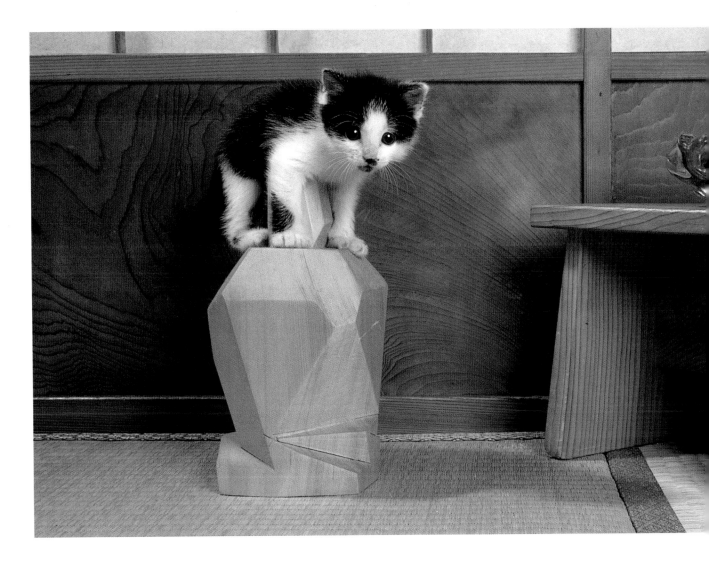

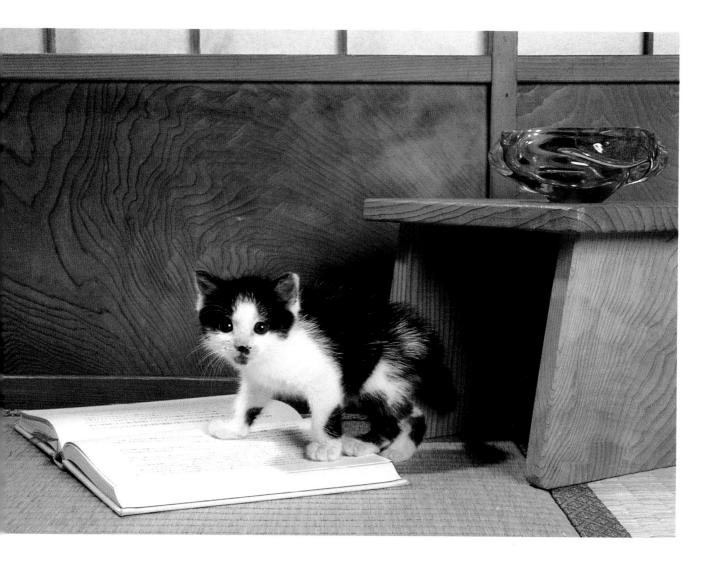

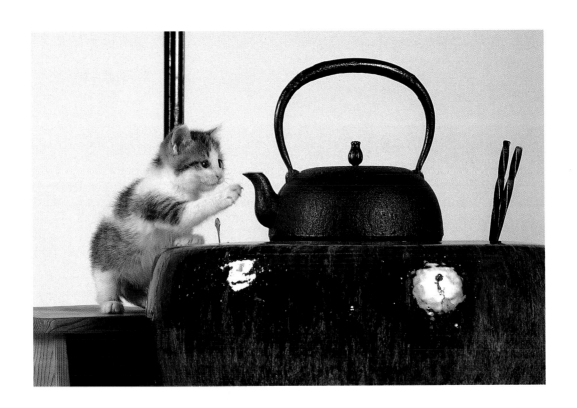

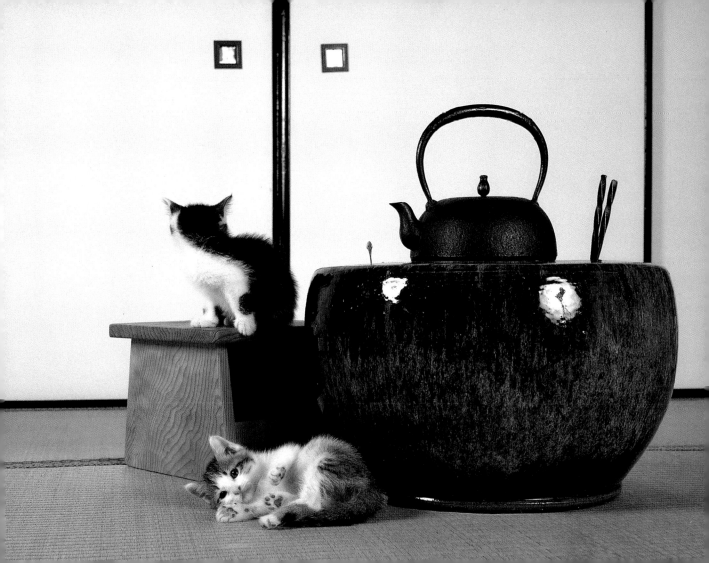

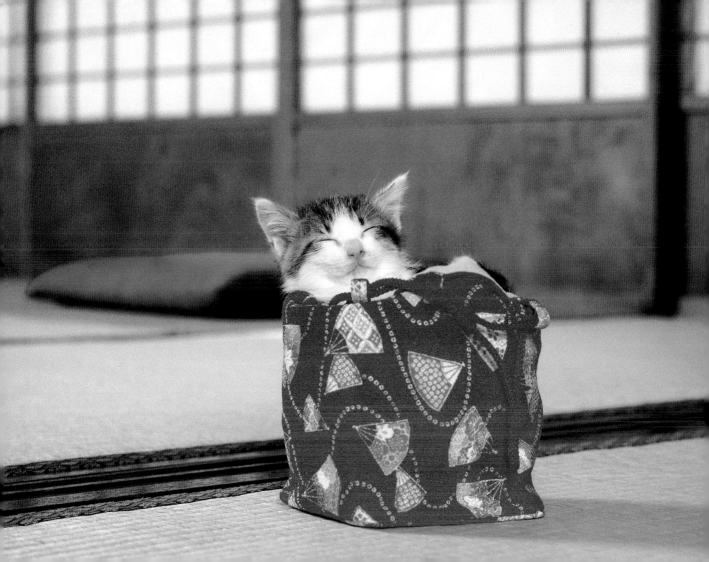

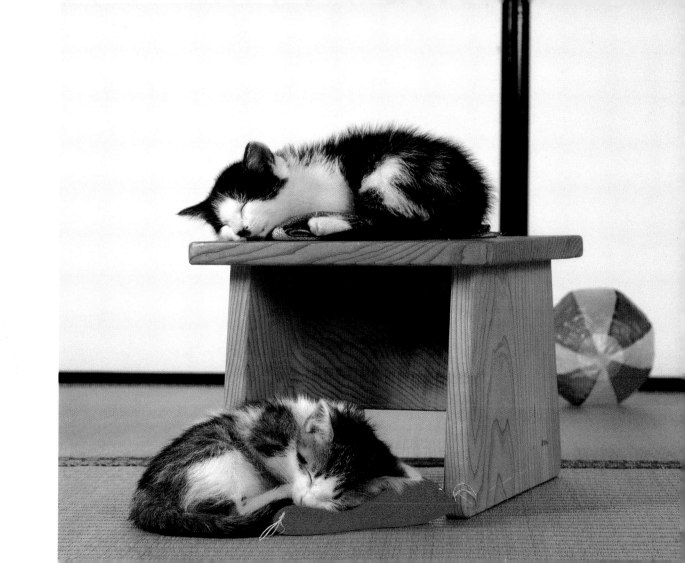

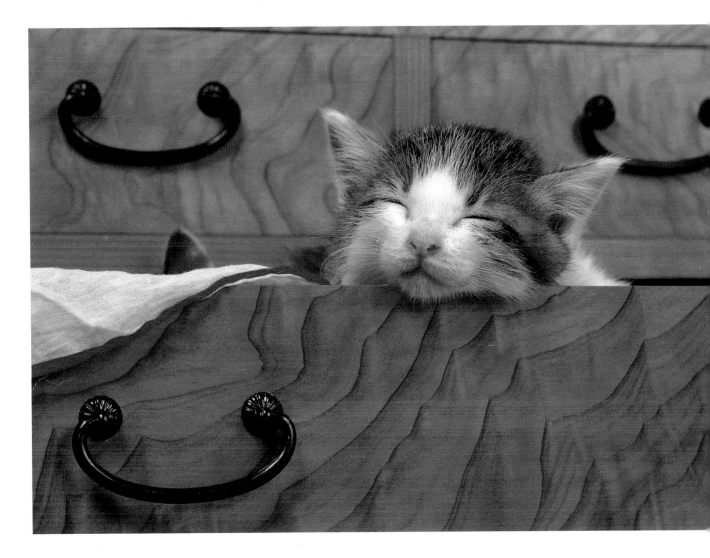

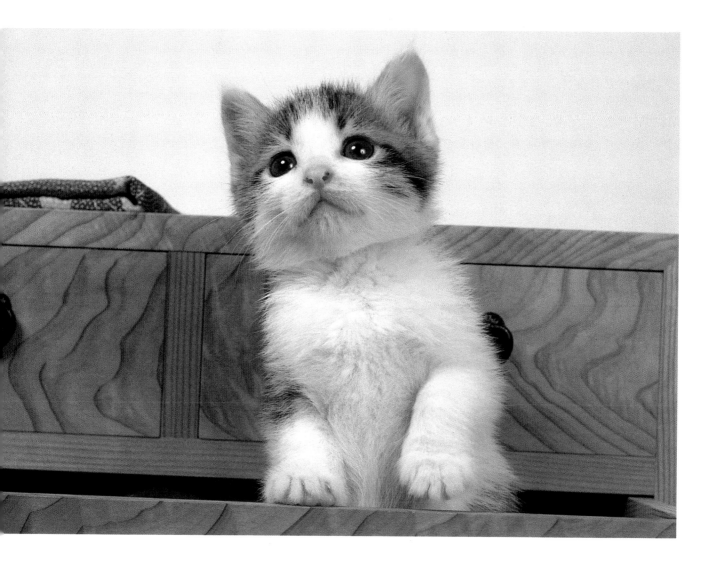

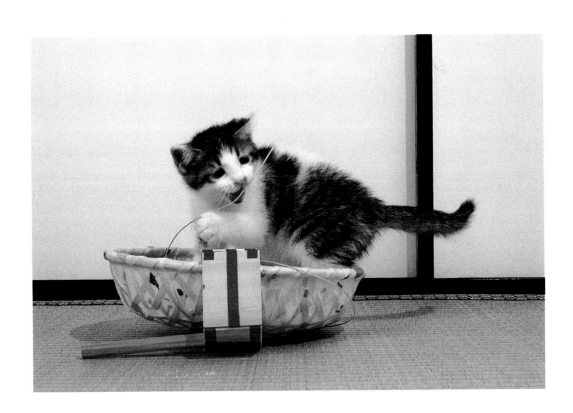

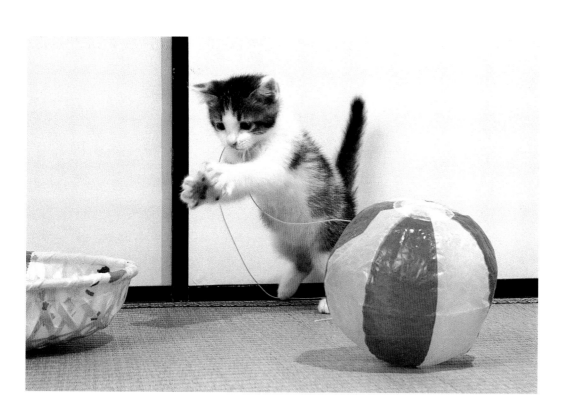

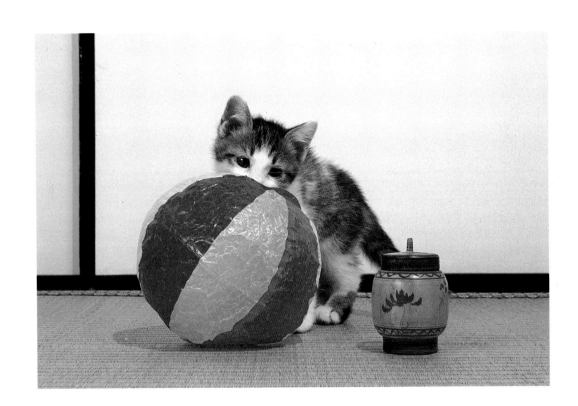

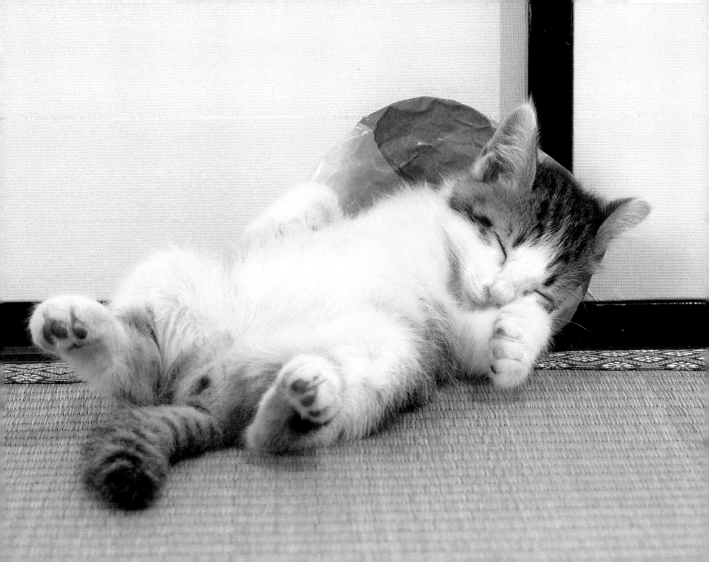

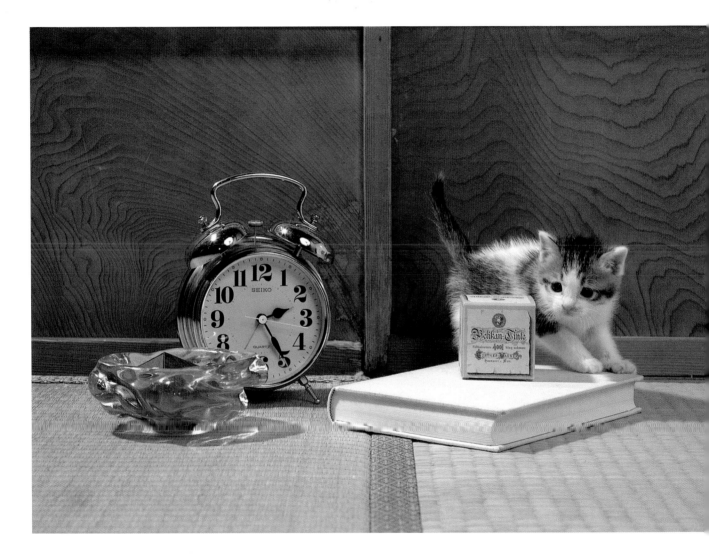

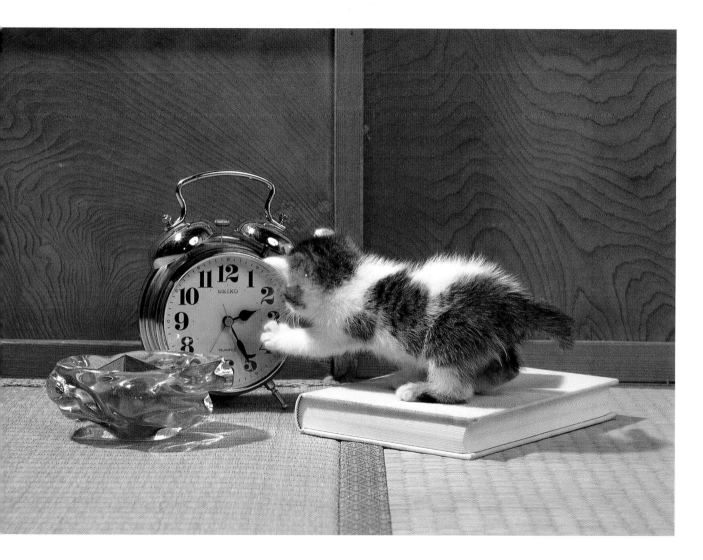

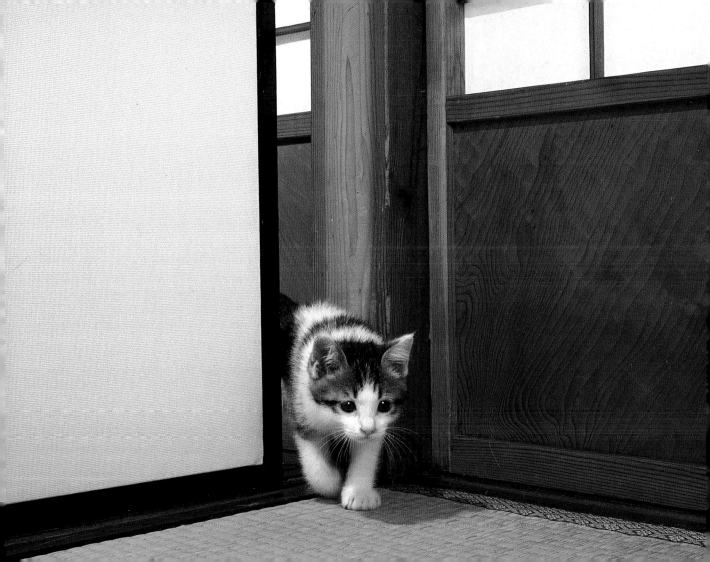

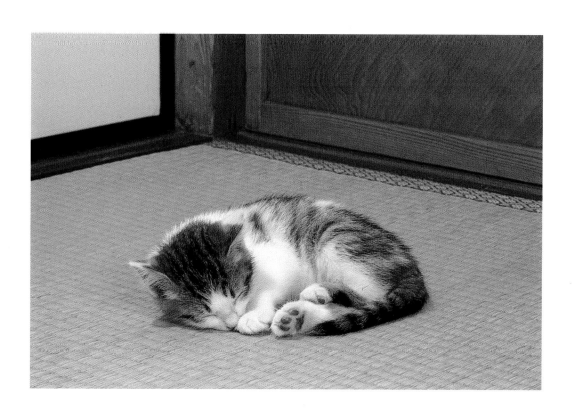

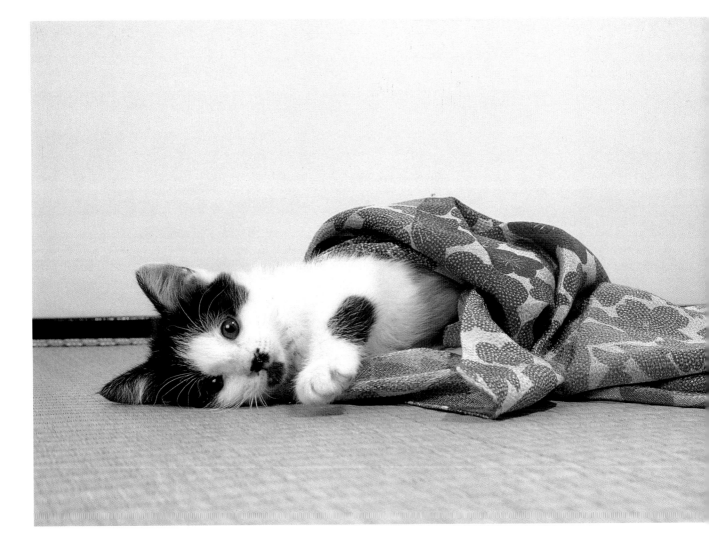

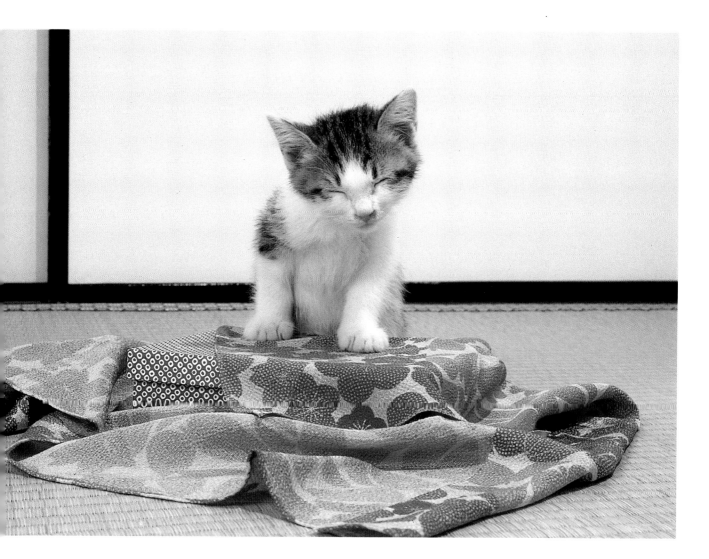

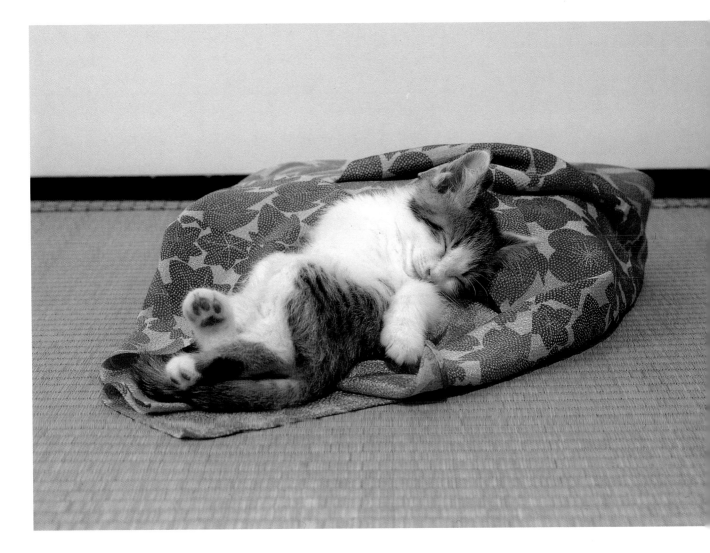

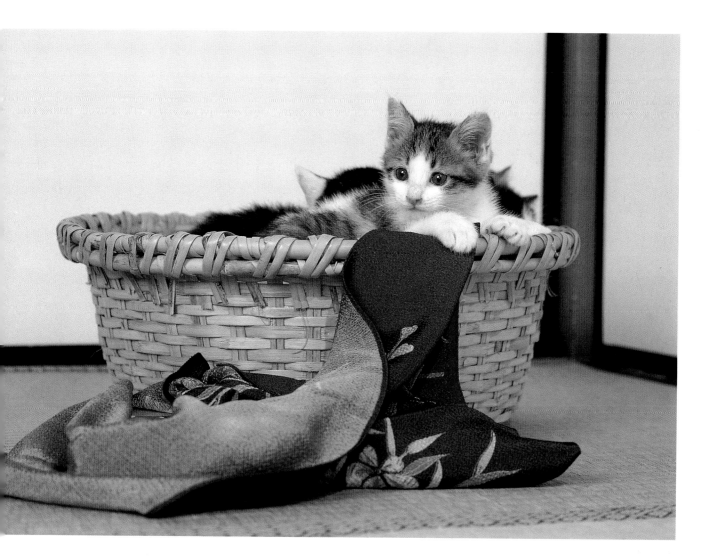

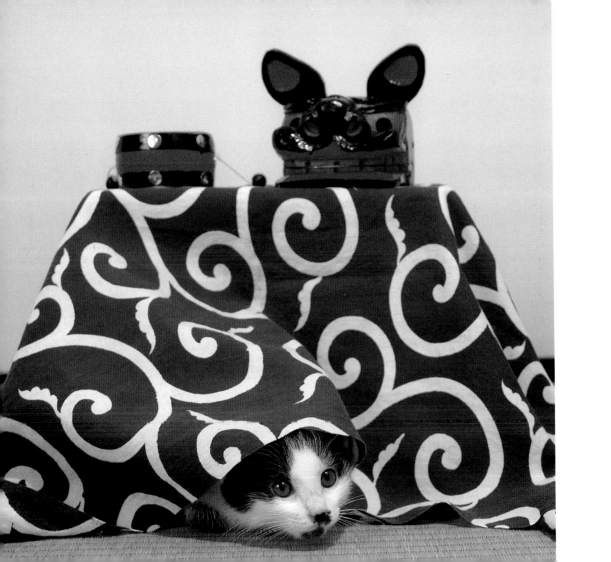

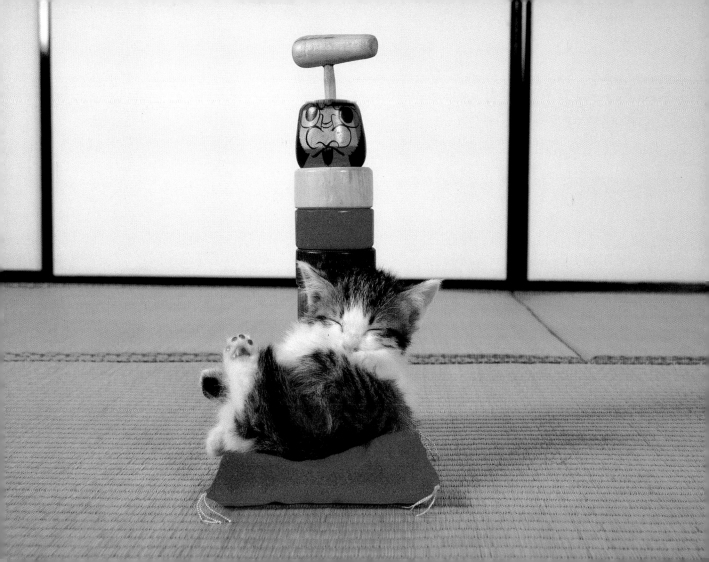

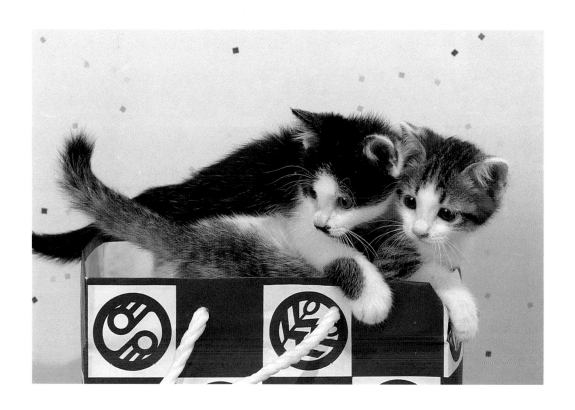

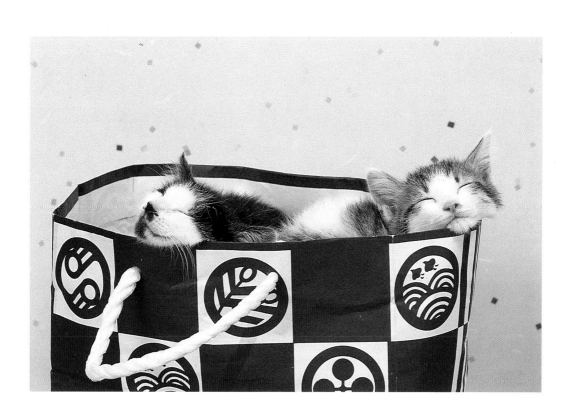

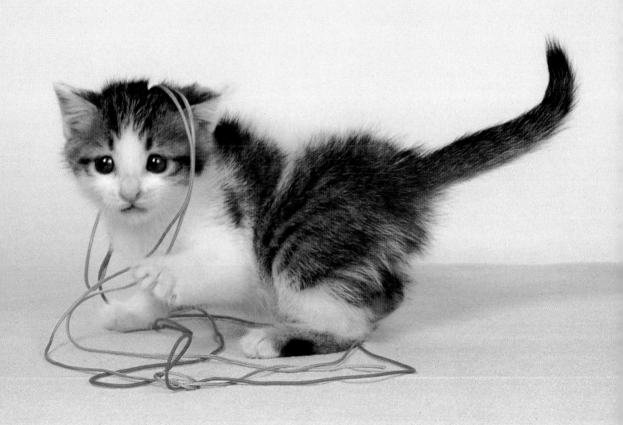

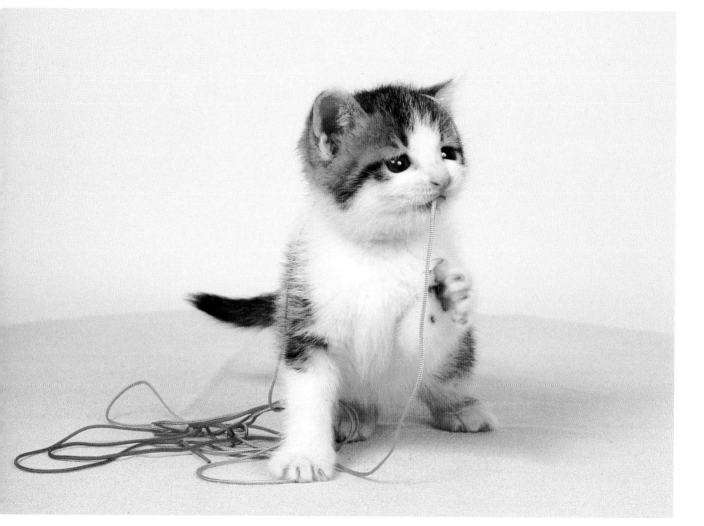

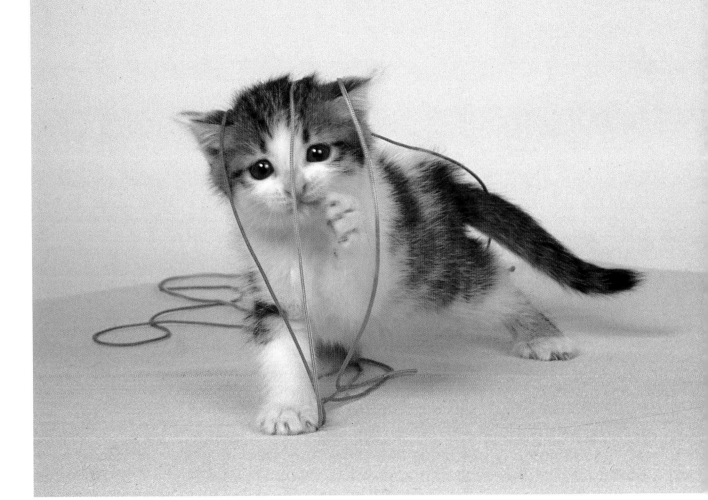

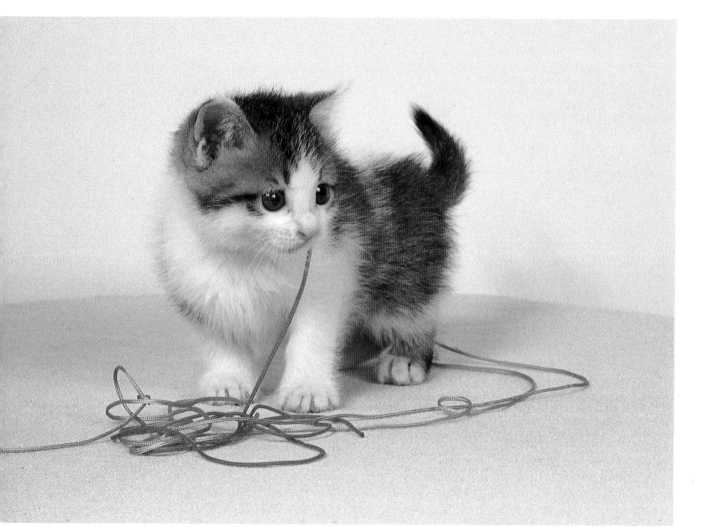

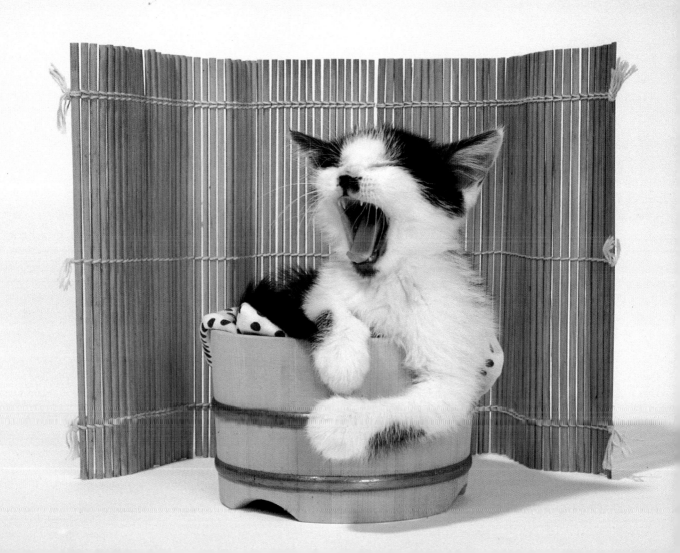

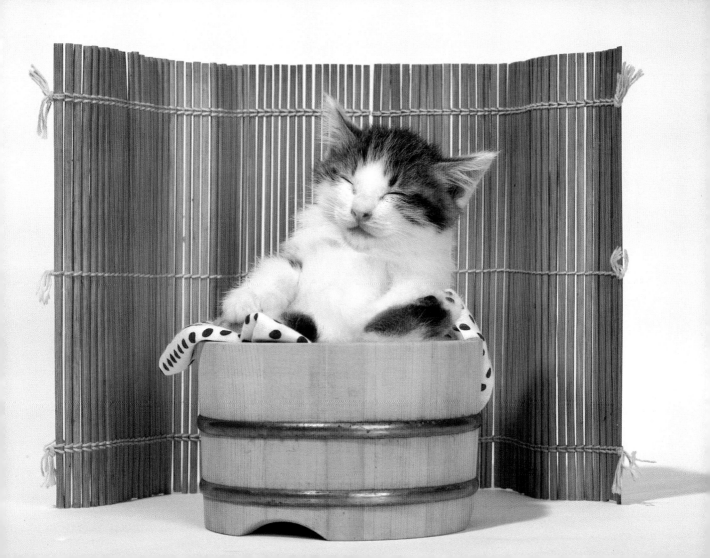

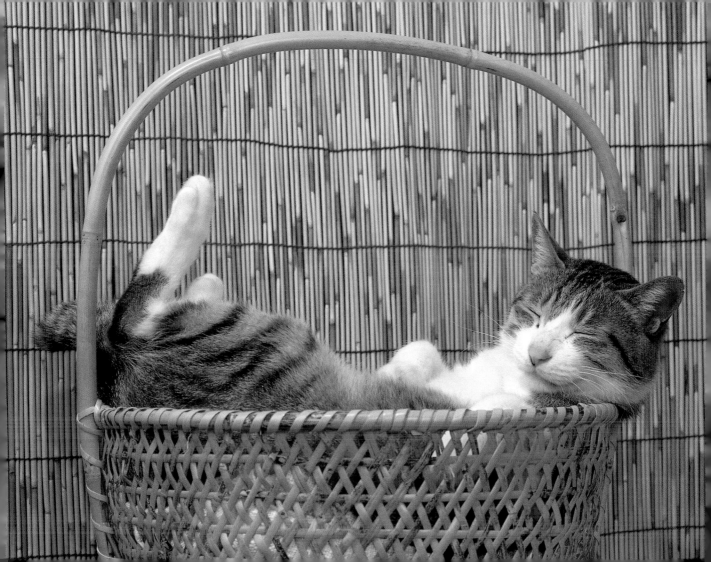

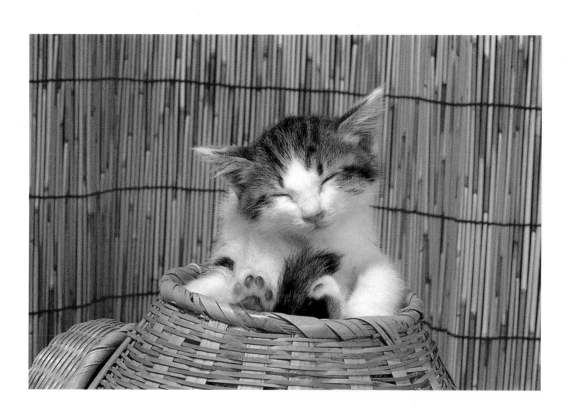

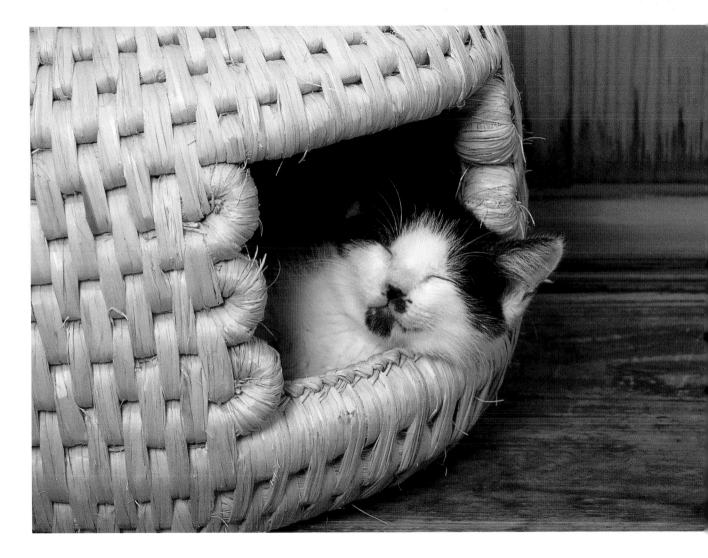

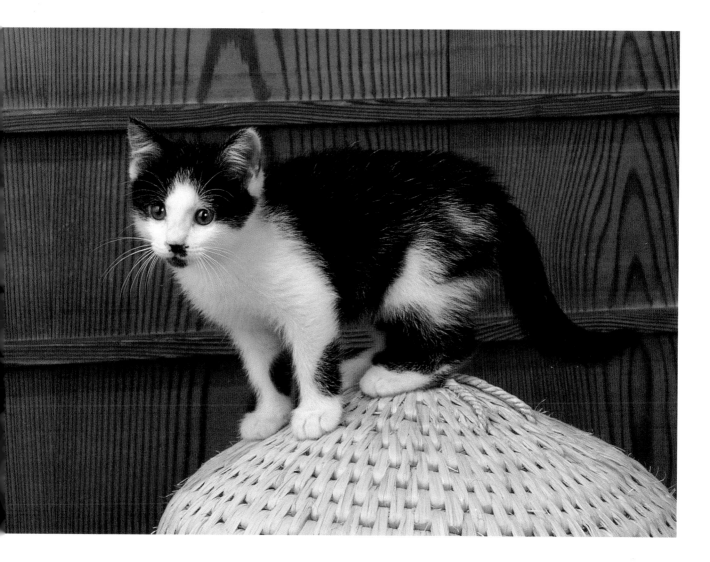

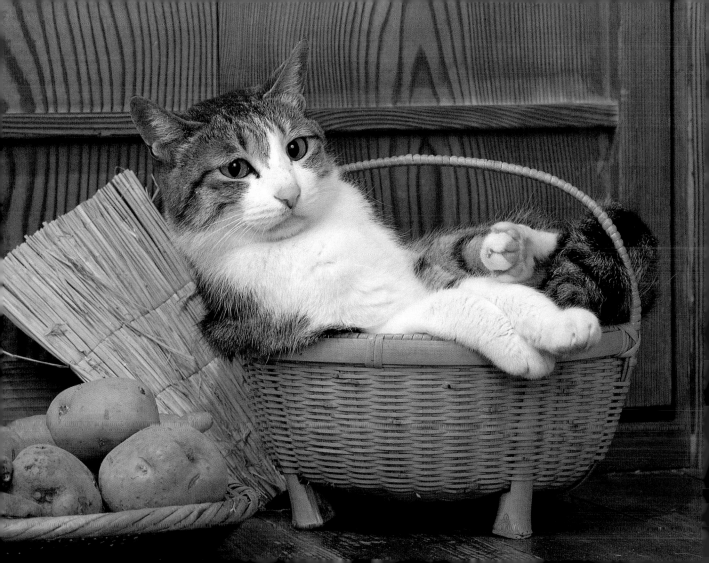

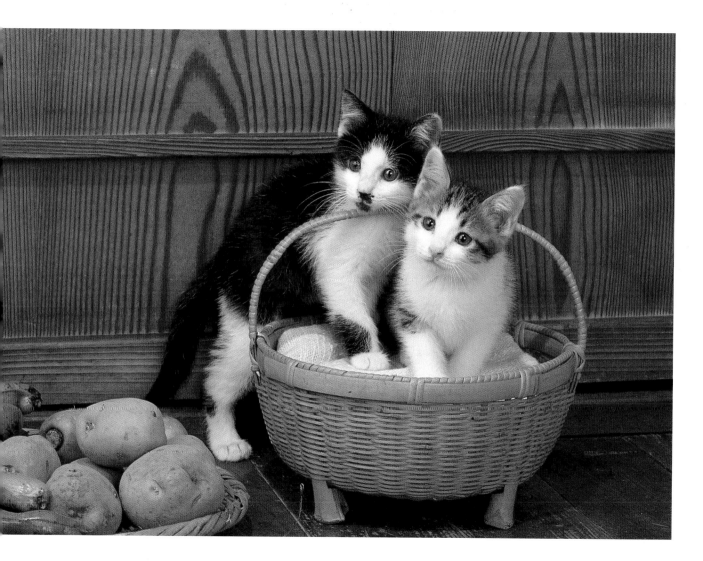

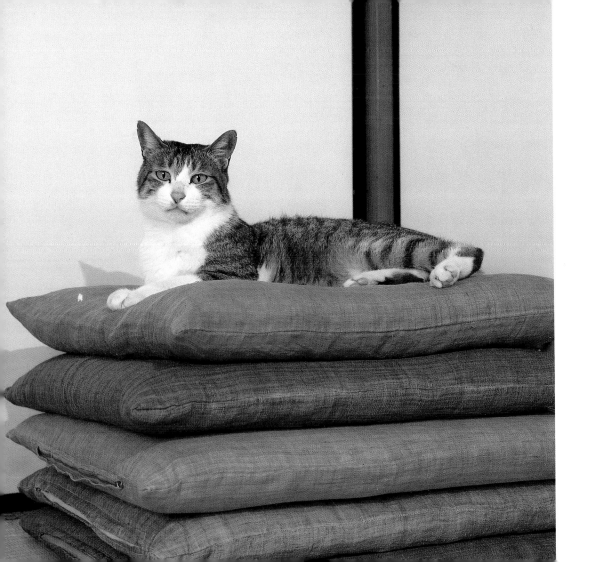

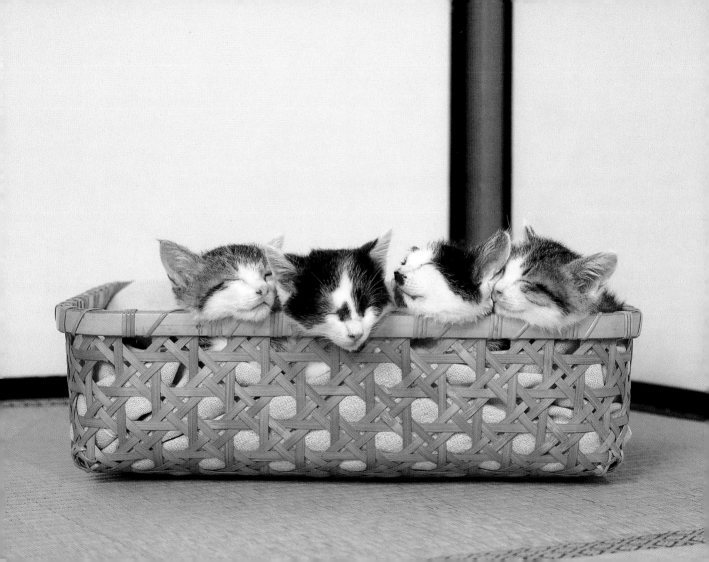

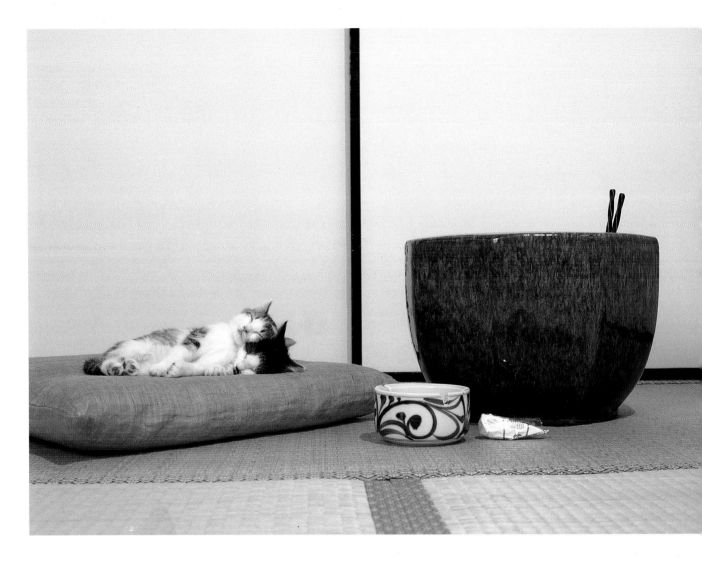

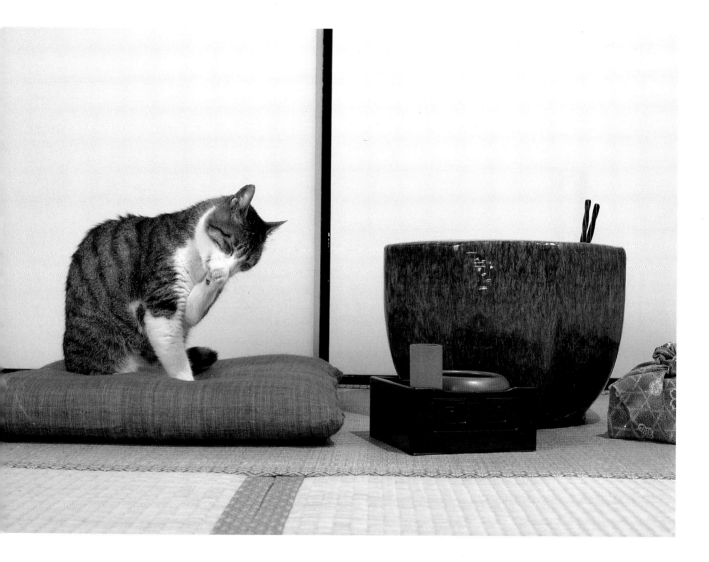

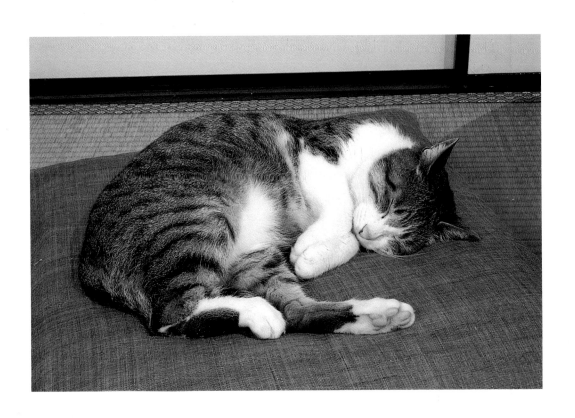